ART OF COLORING

Disney

Beauty
AND THE
Beast

100 IMAGES TO INSPIRE CREATIVITY

"Beauty and the Beast" song lyrics:
Music by Alan Menken
Lyrics by Howard Ashman
© 1991 Walt Disney Music Company and Wonderland Music Company, Inc.

Copyright © 2017 Disney Enterprises, Inc.

For information address Disney Editions, 1200 Grand Central Avenue, Glendale, California 91201.

Printed in the United States of America

First United States English Edition, January 2017
5 7 9 10 8 6

ISBN 978-1-4847-8972-8

FAC-014353-19009

Visit www.disneybooks.com

ART OF COLORING

Disney
BEAUTY
AND THE
BEAST

100 IMAGES TO INSPIRE CREATIVITY

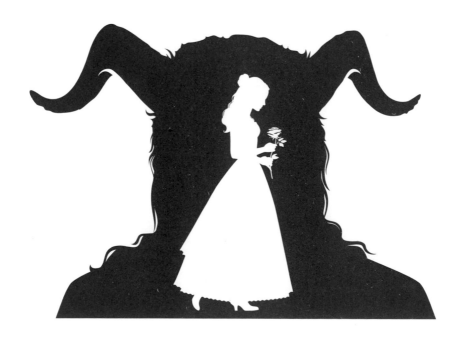

DISNEP
EDITIONS

Los Angeles · New York

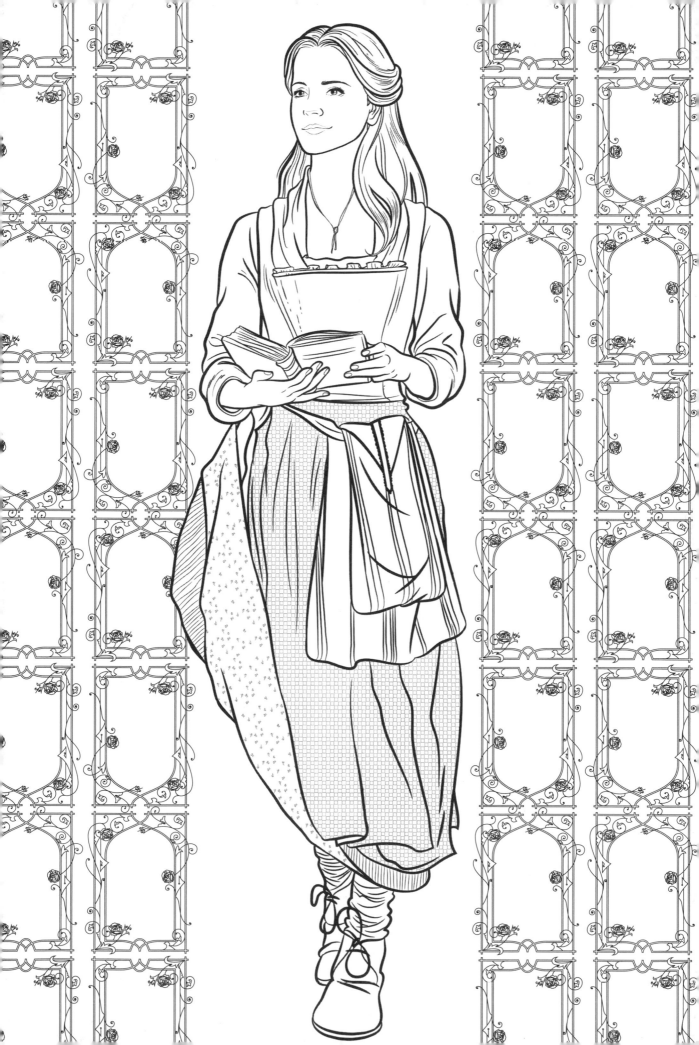

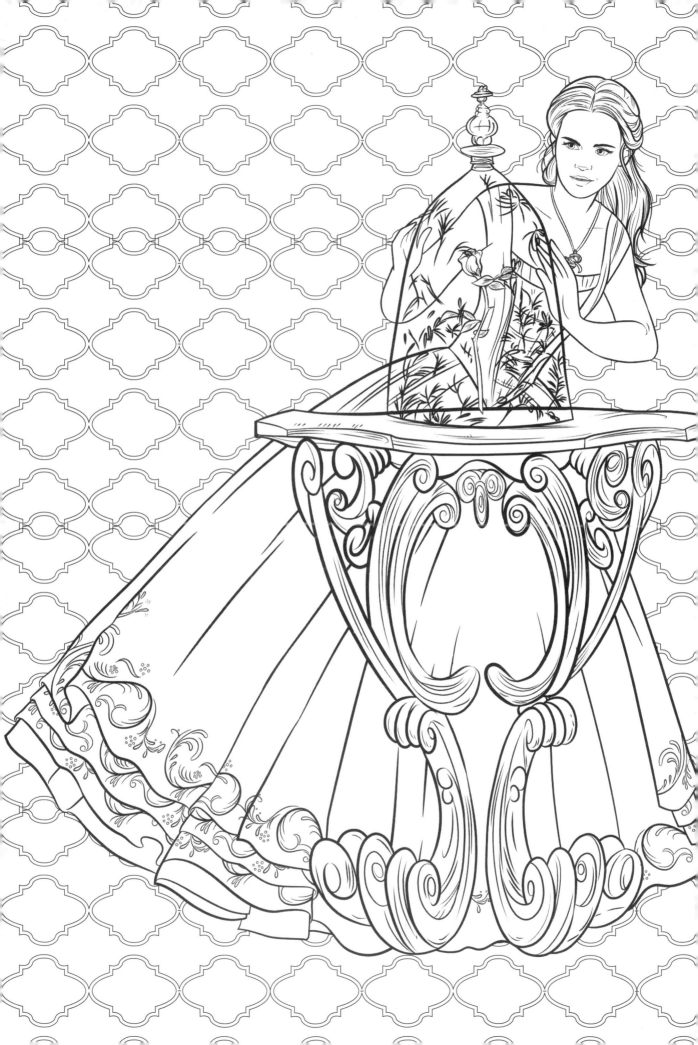

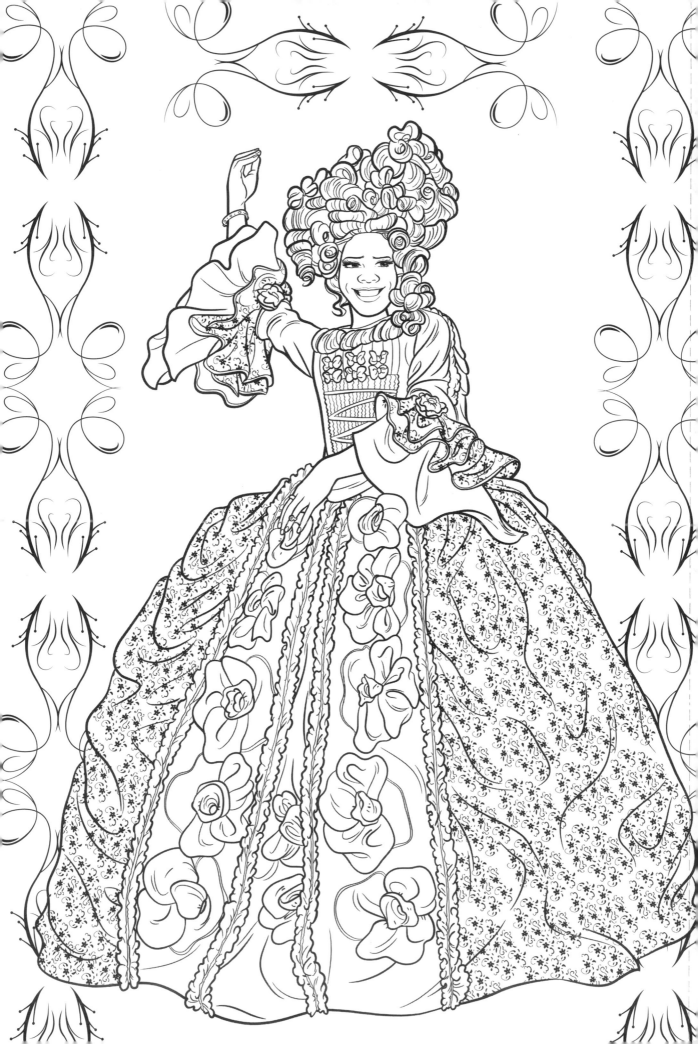

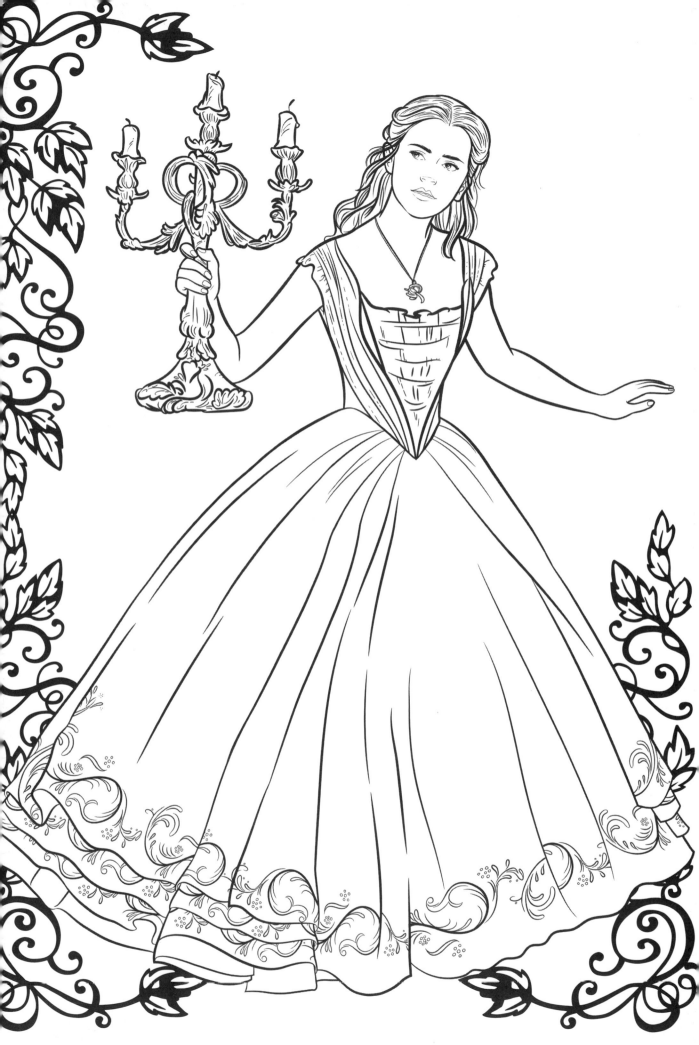

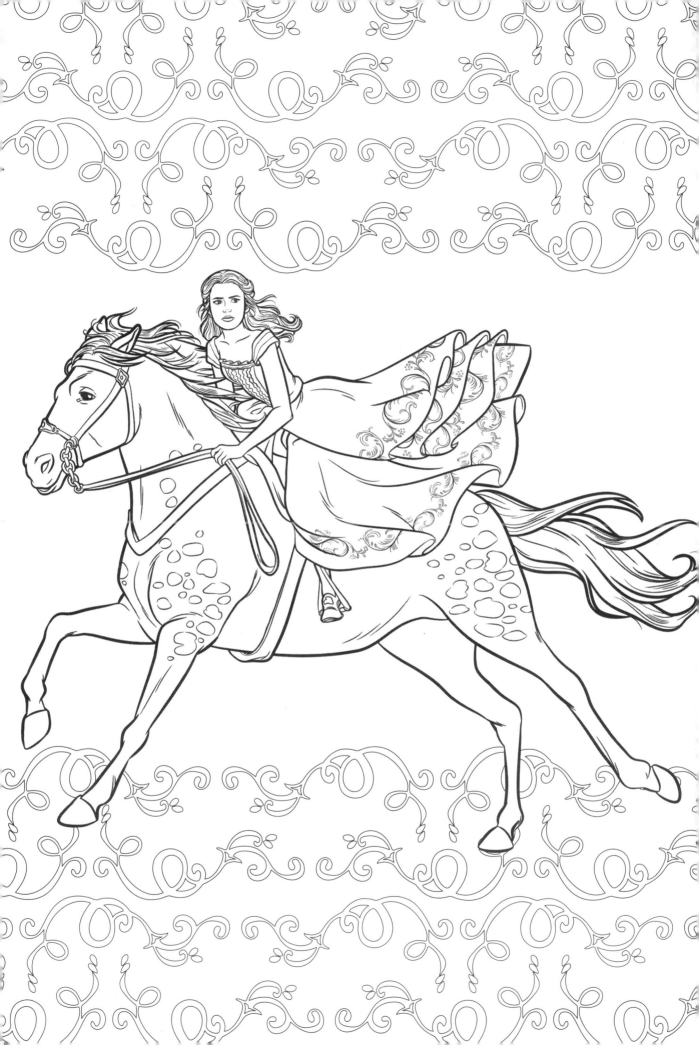

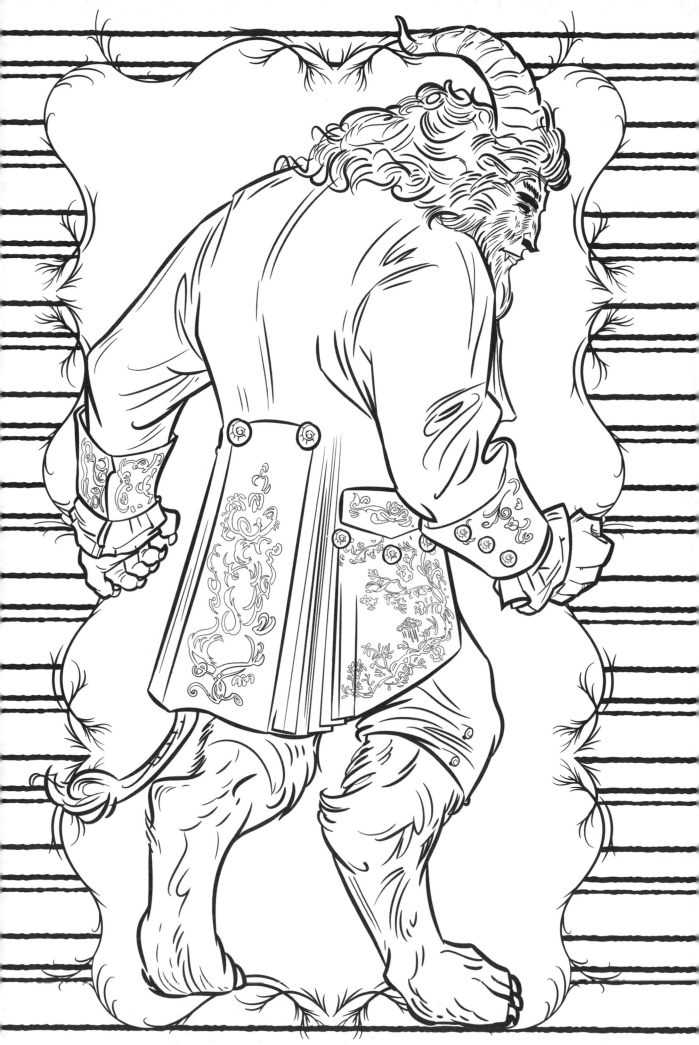

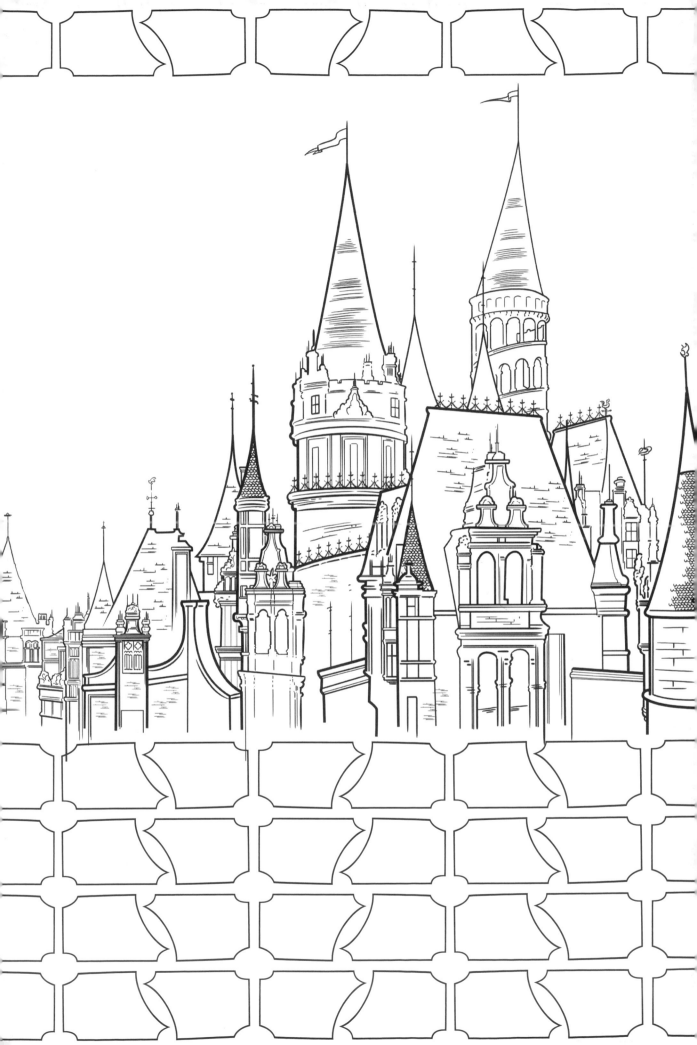

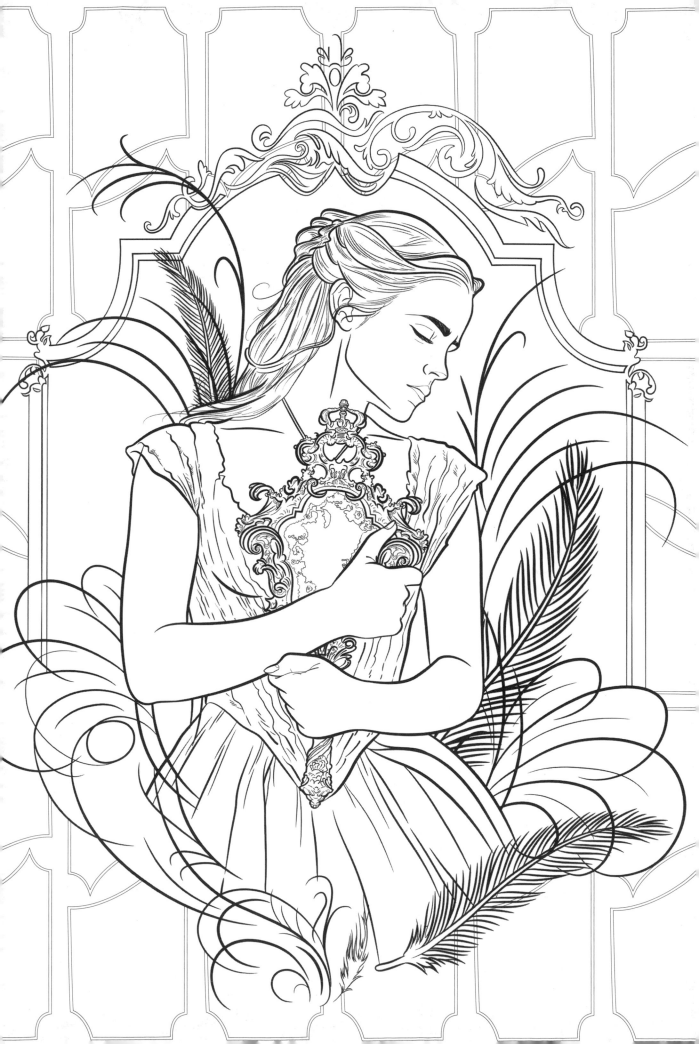

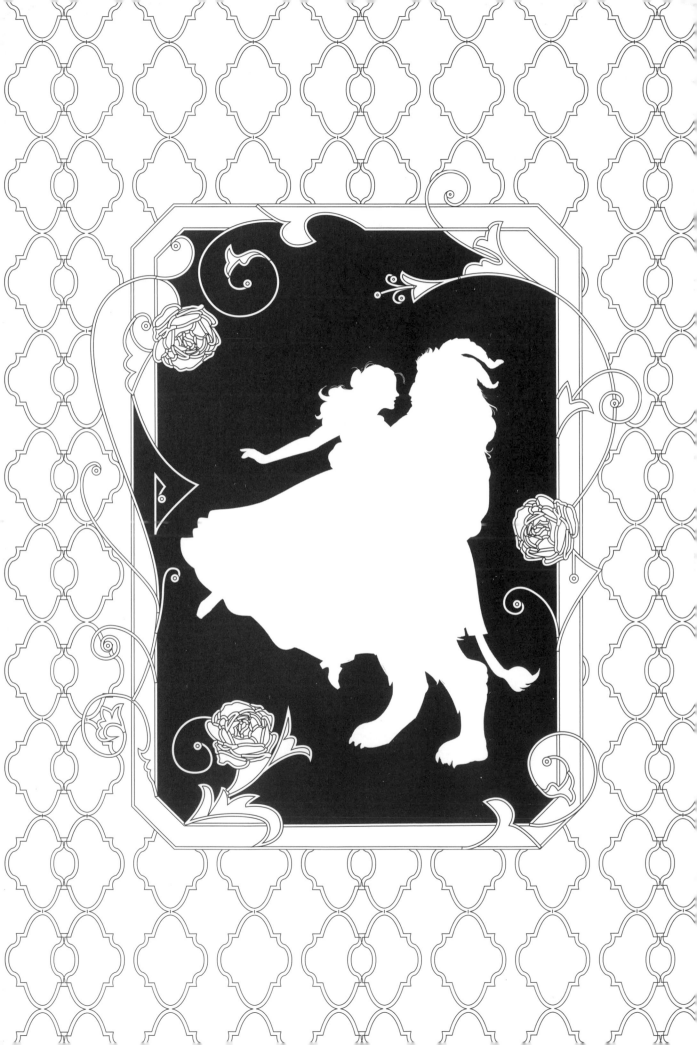

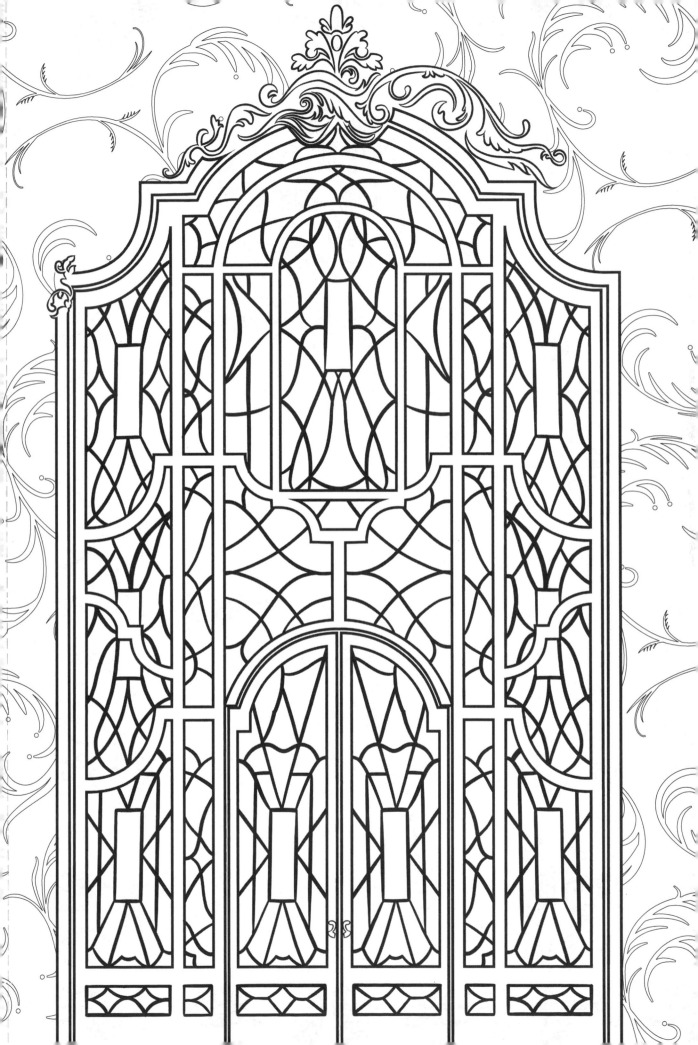

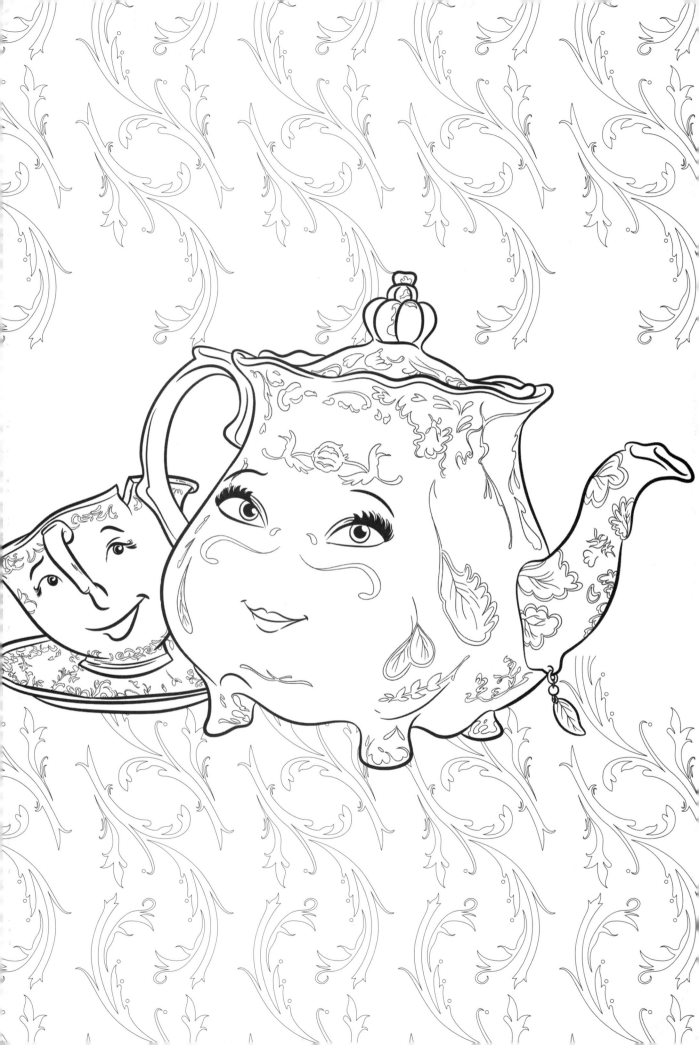

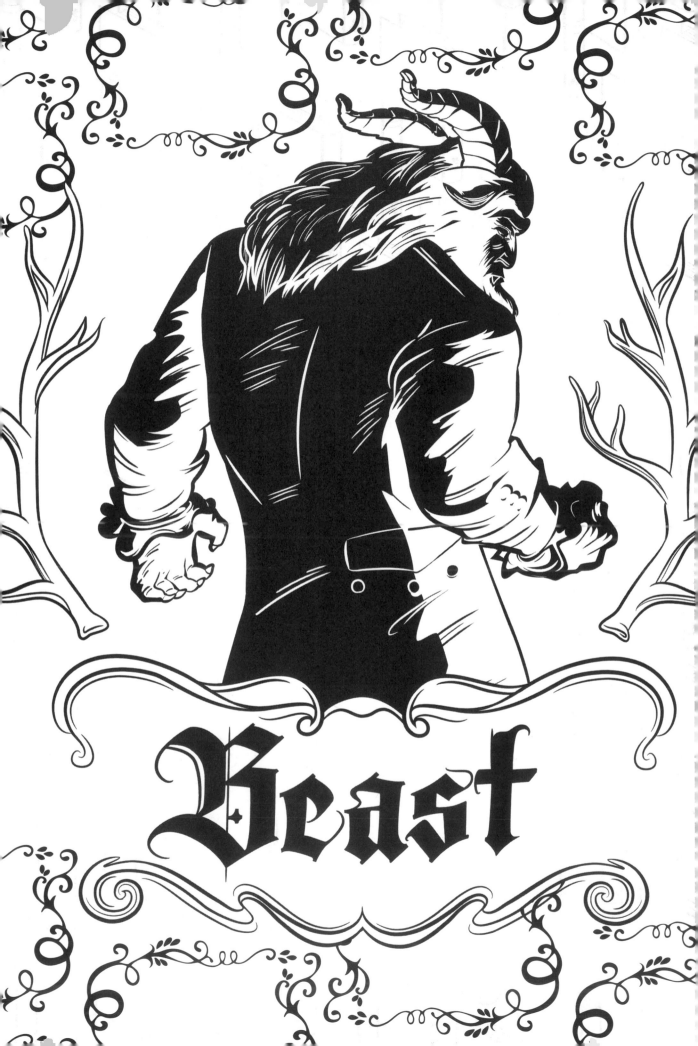

Beast

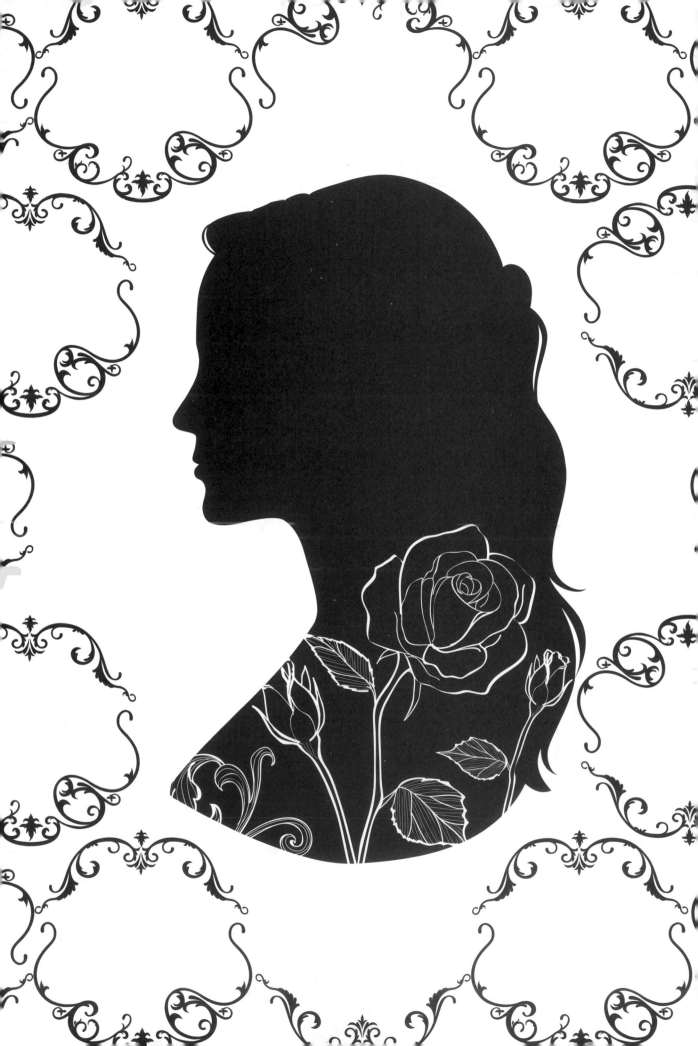

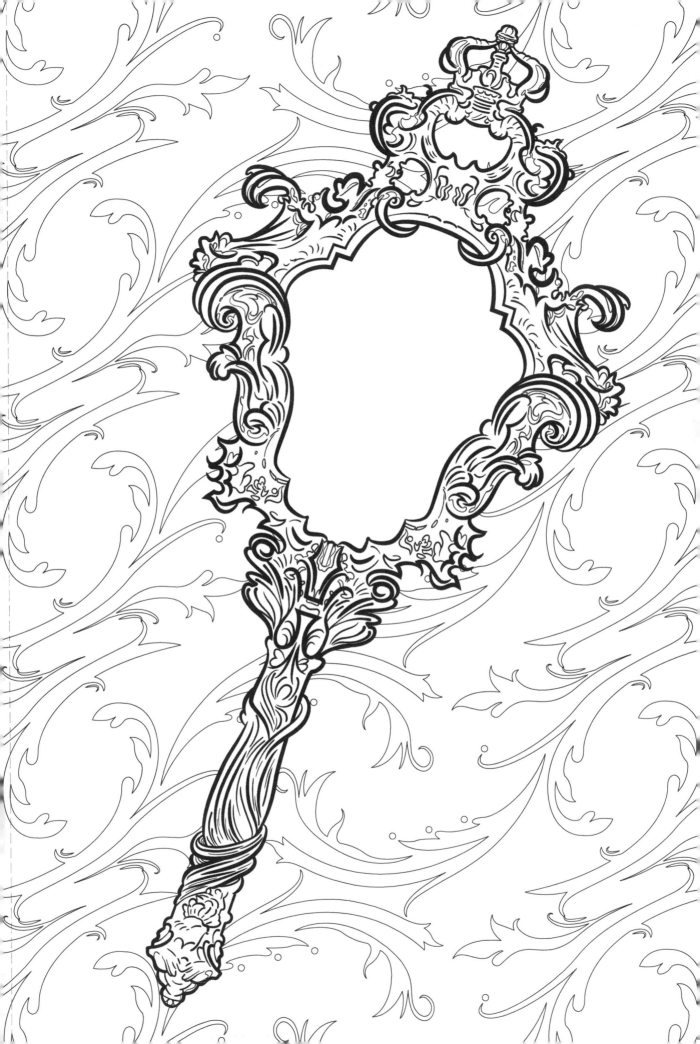

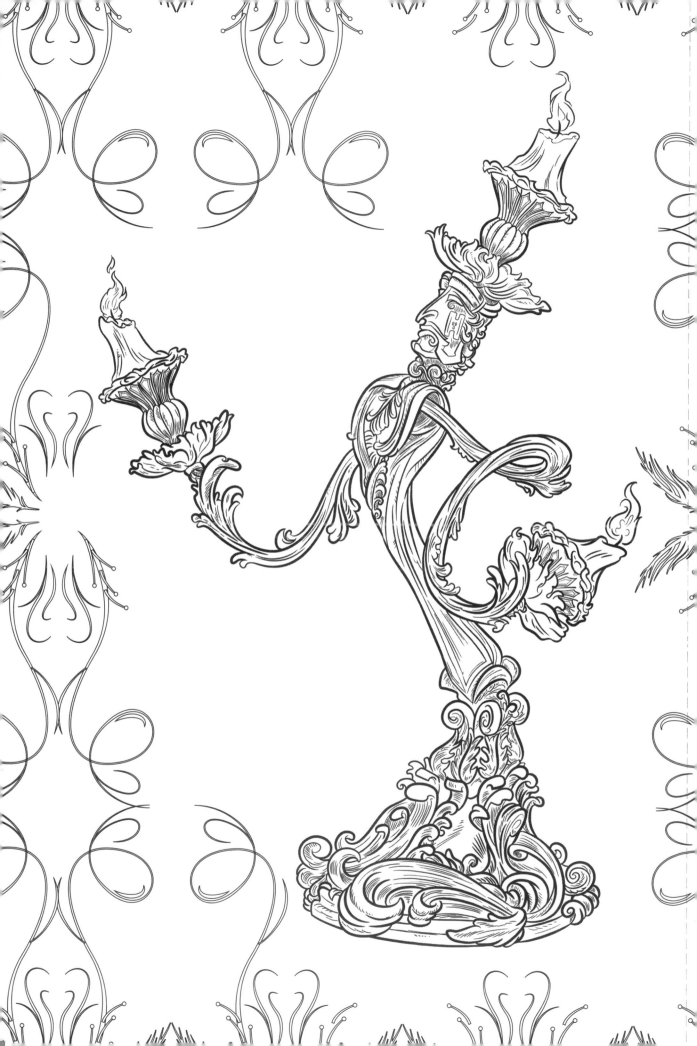

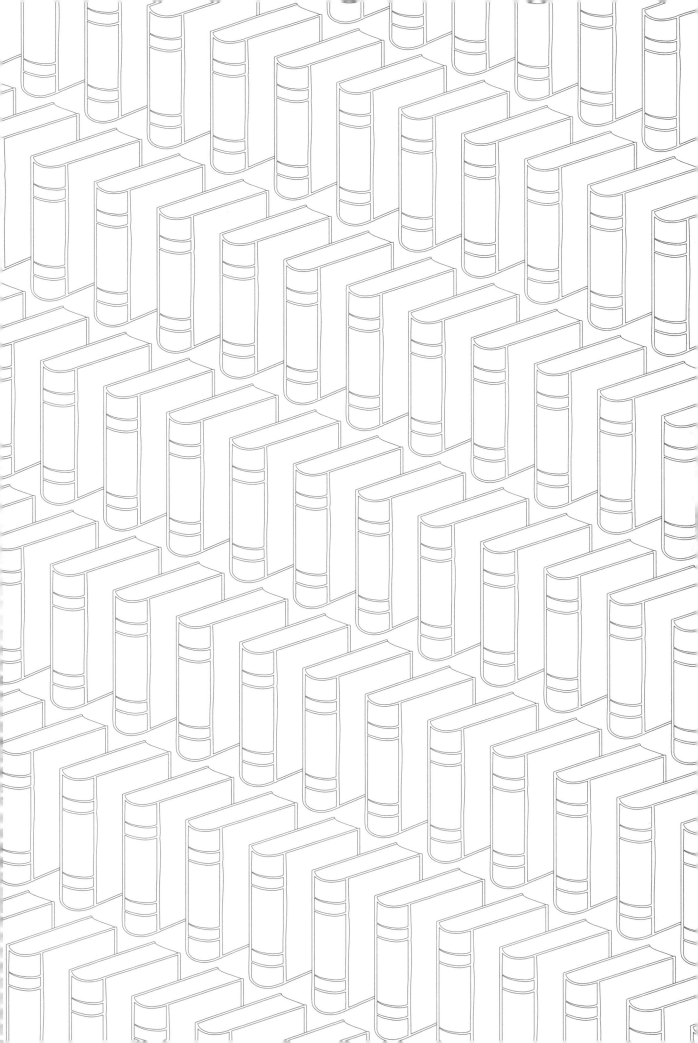

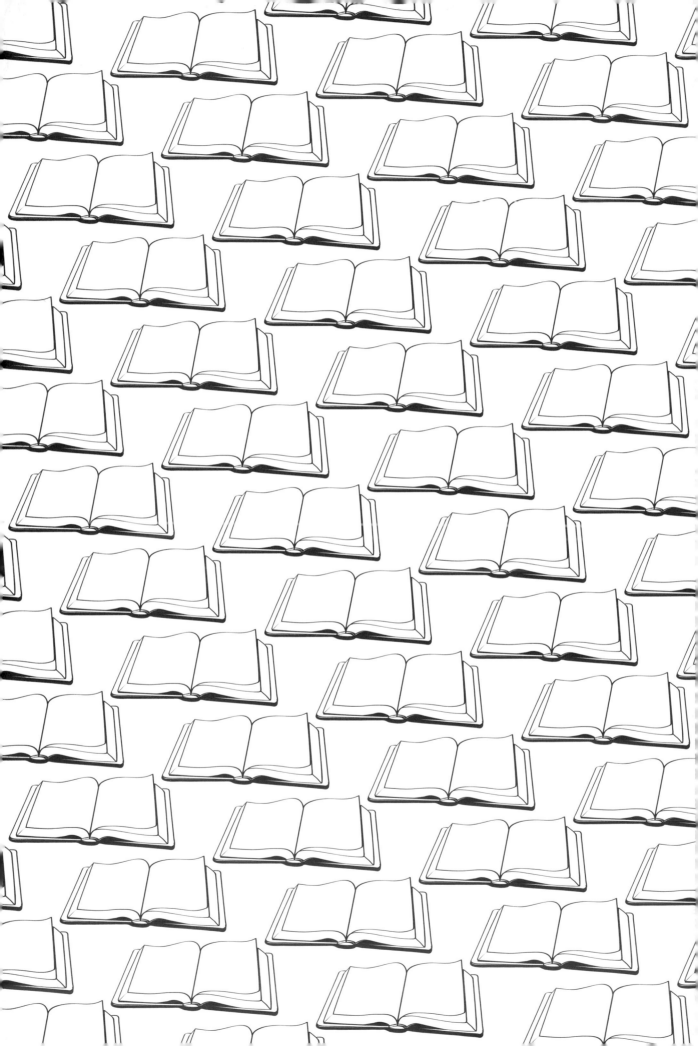

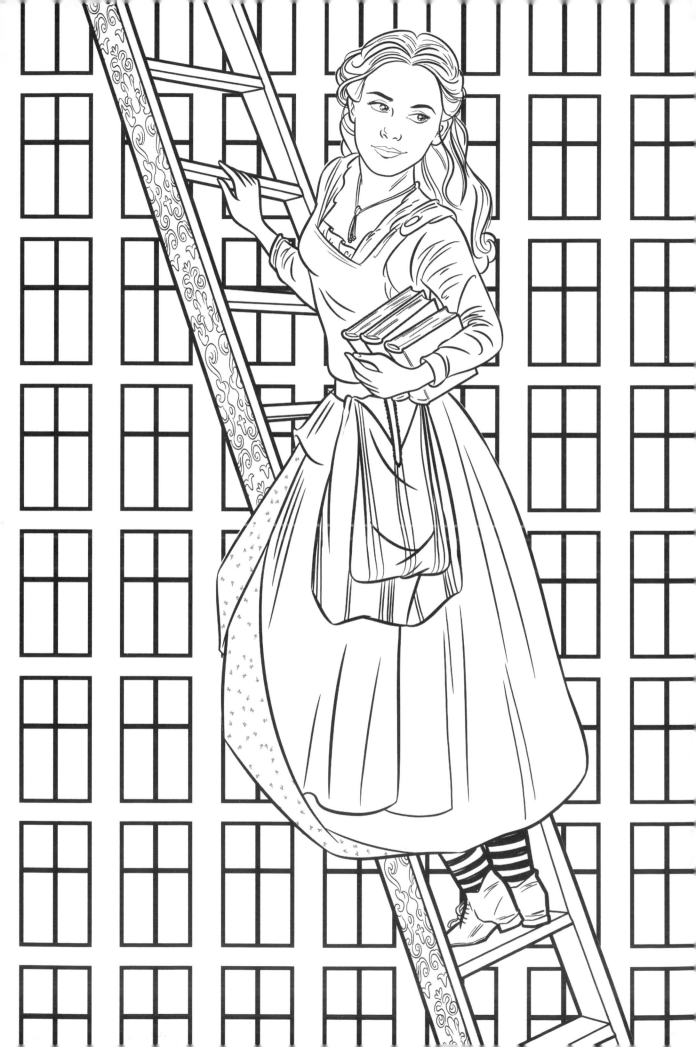

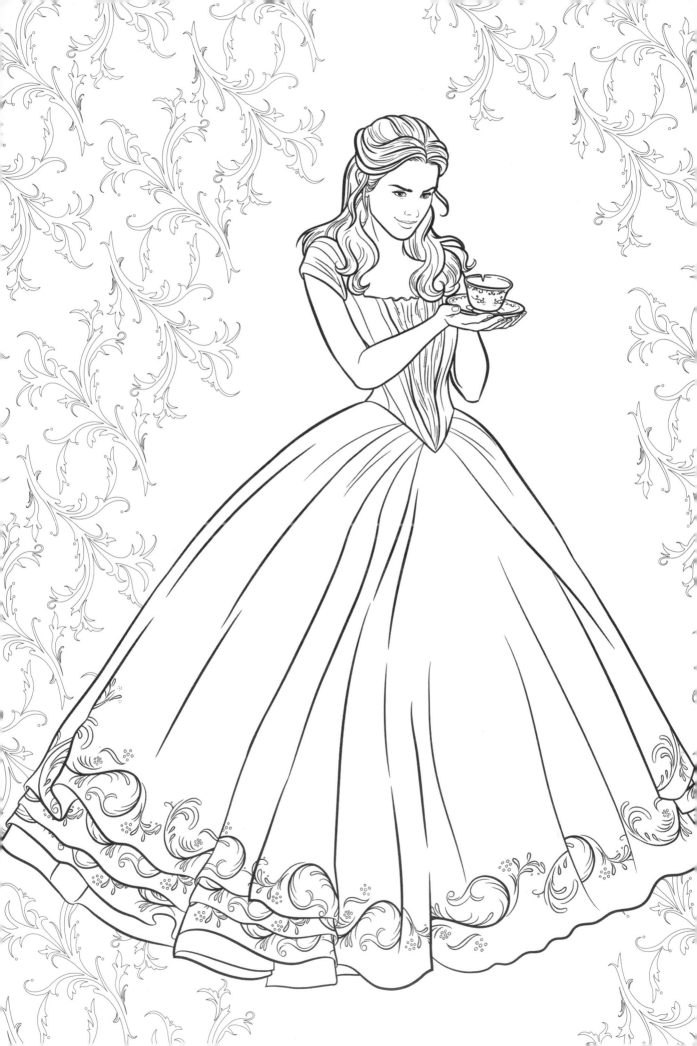

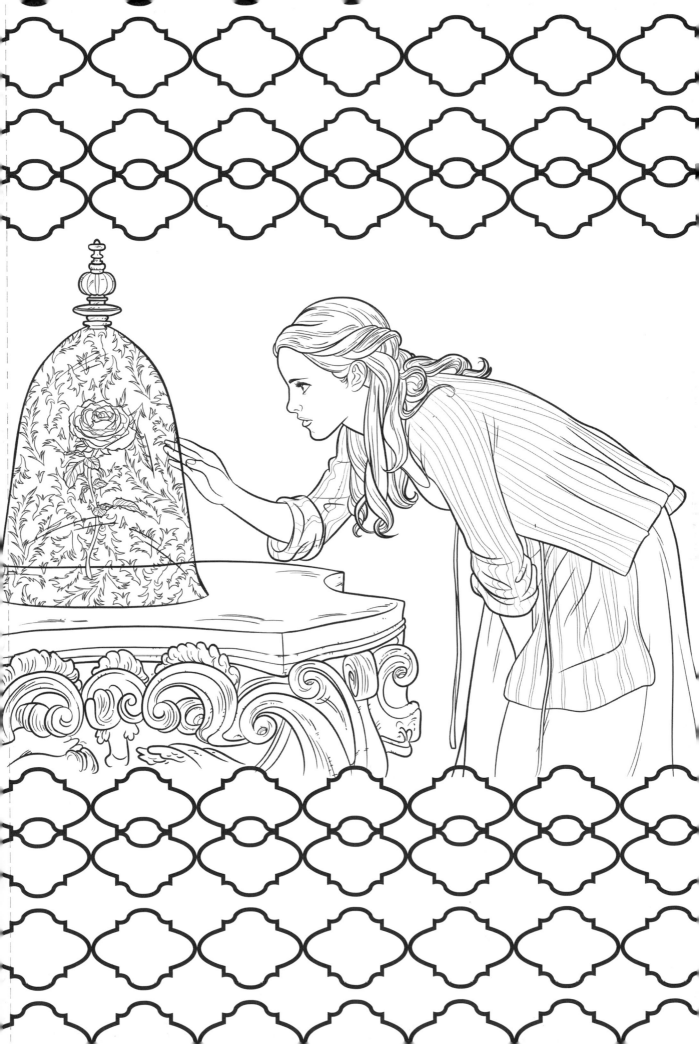

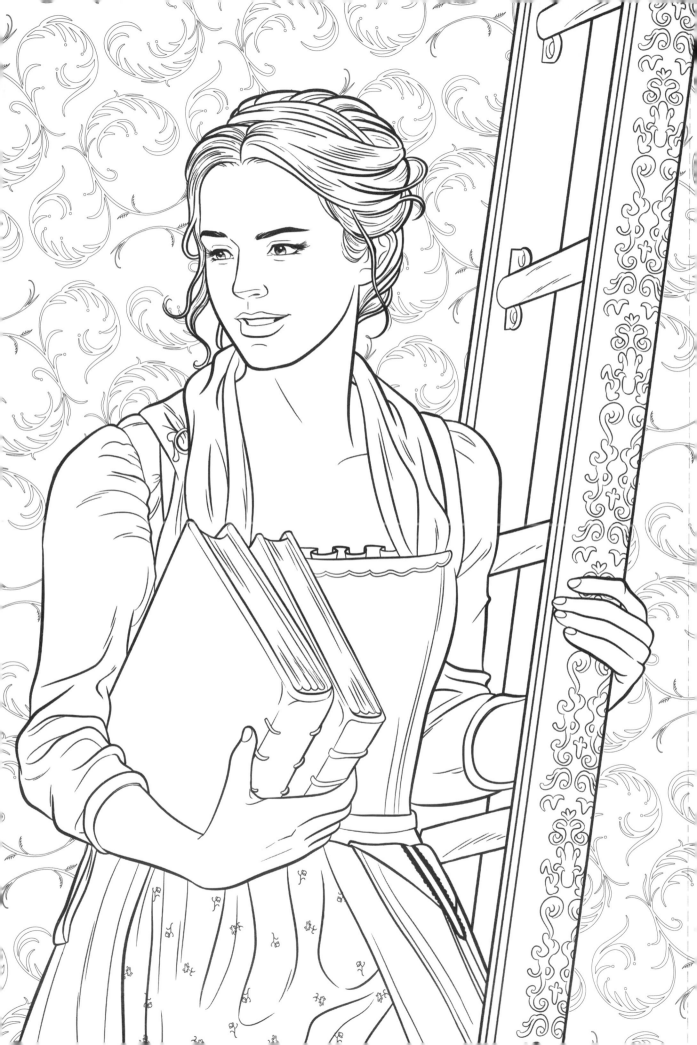

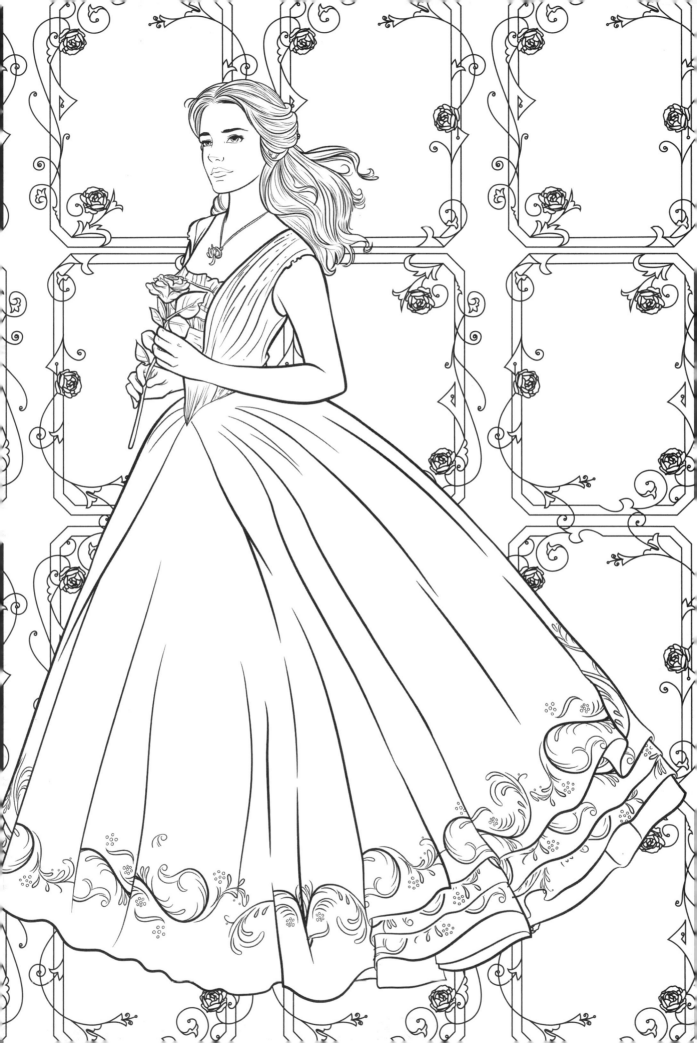

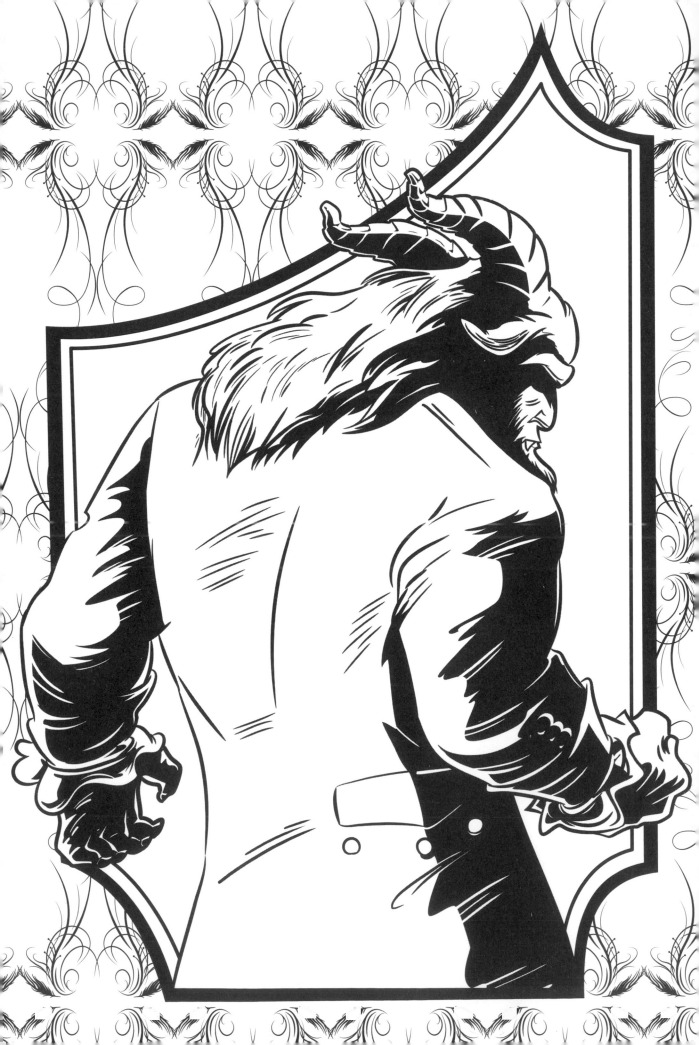

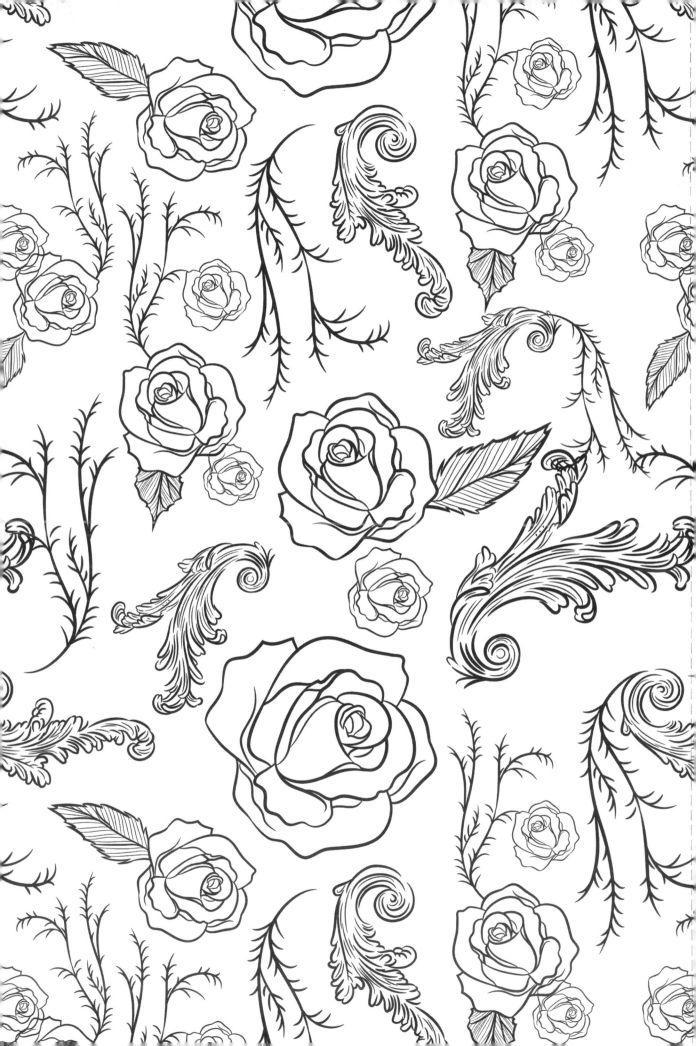

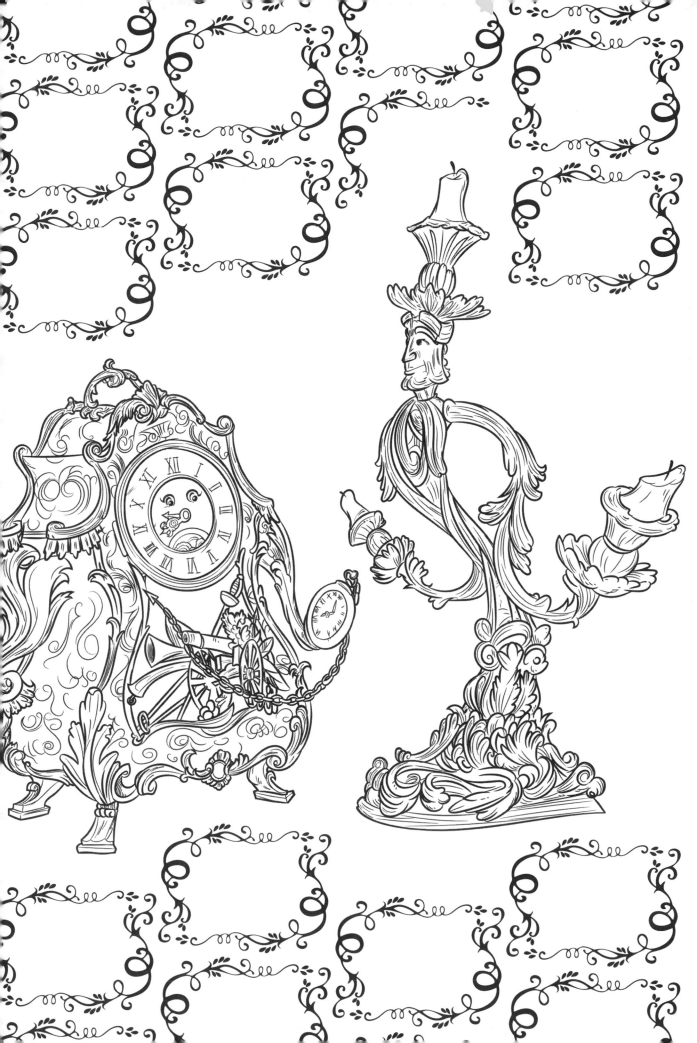

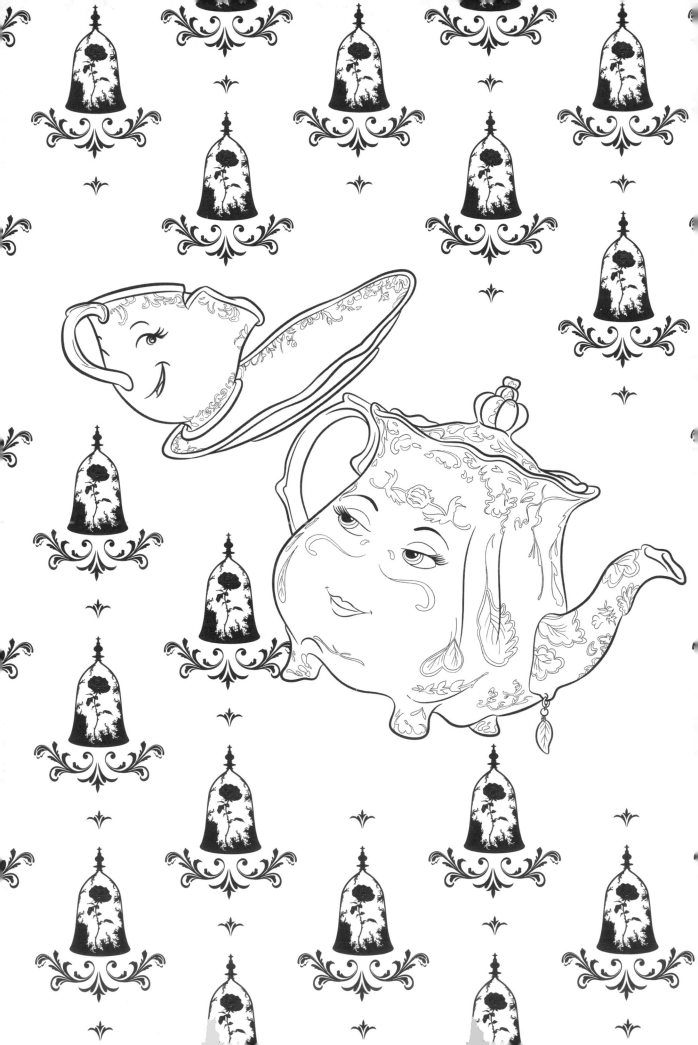

Tale as old as time

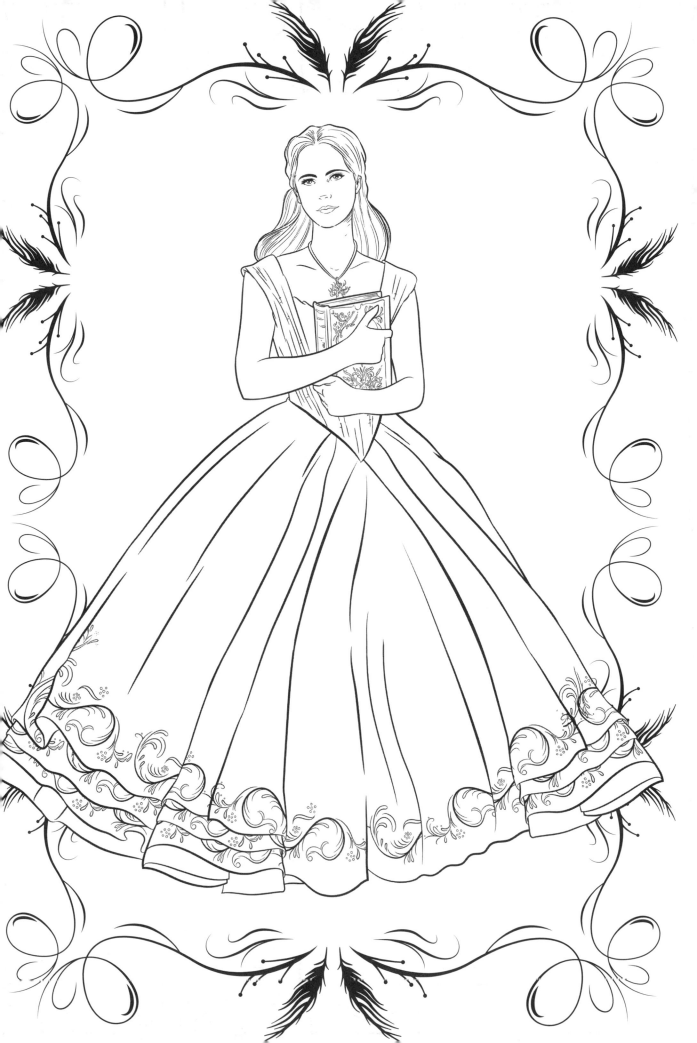

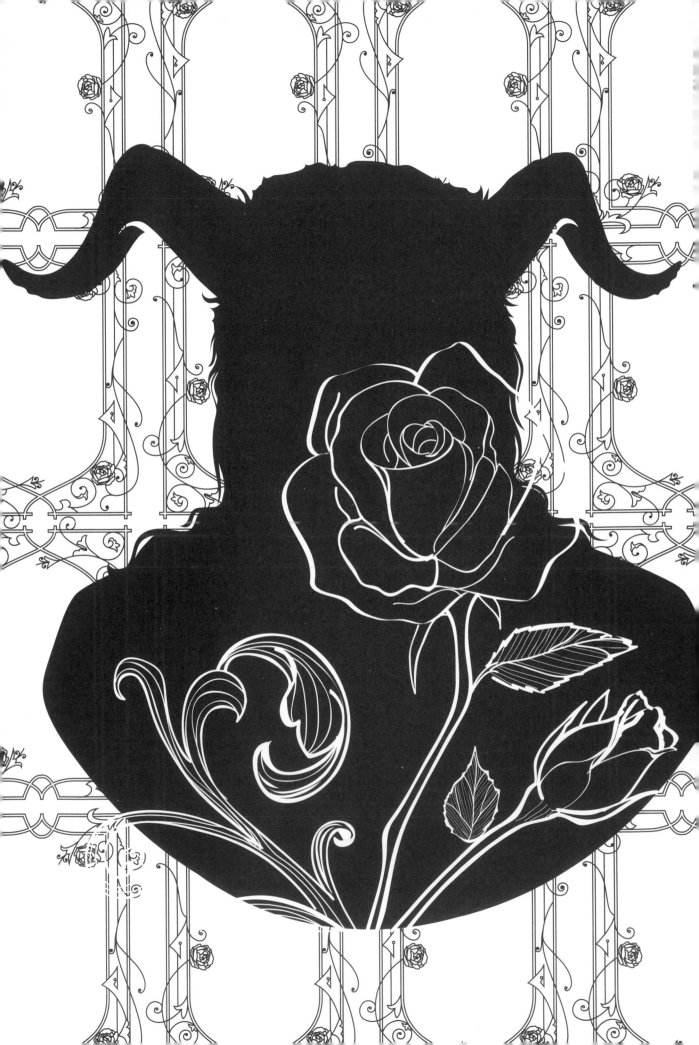

True as it can be

Barely even friends

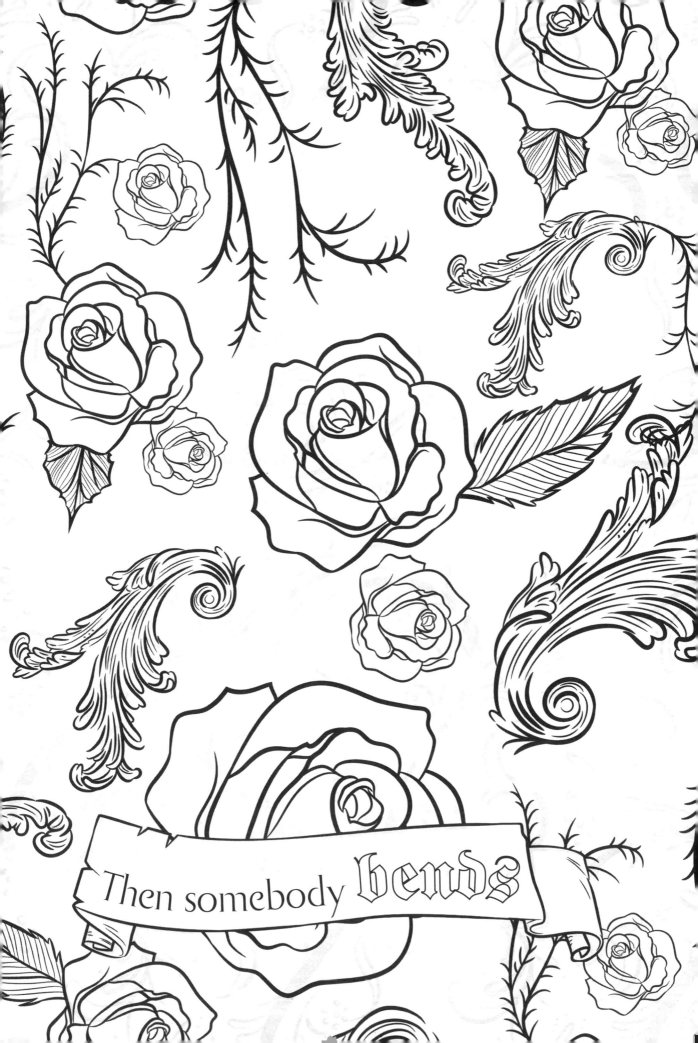

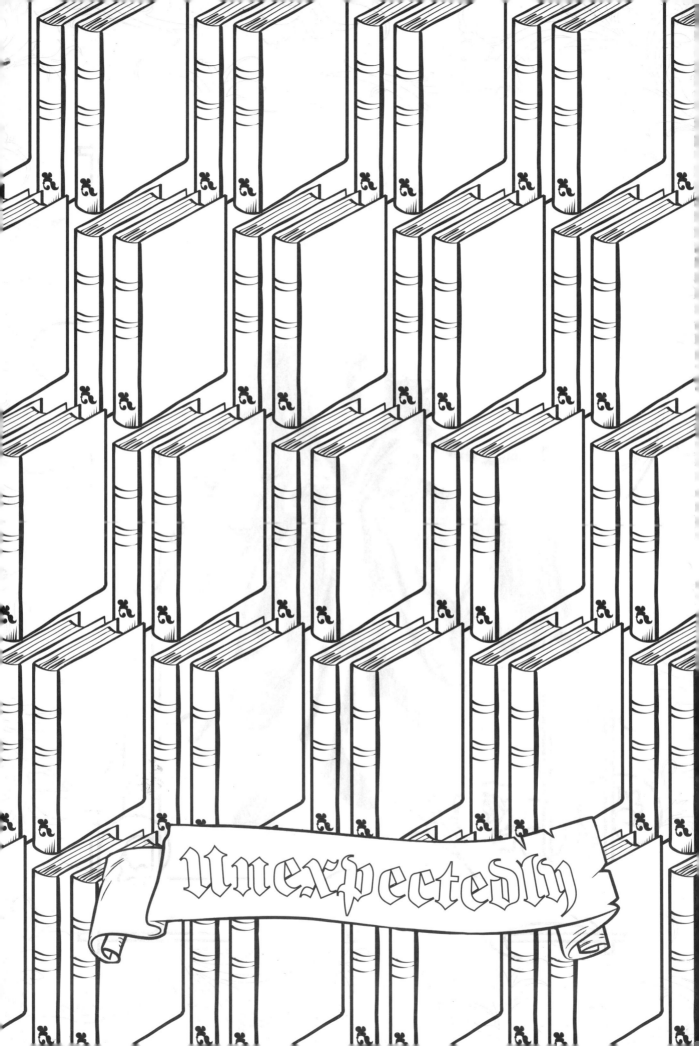

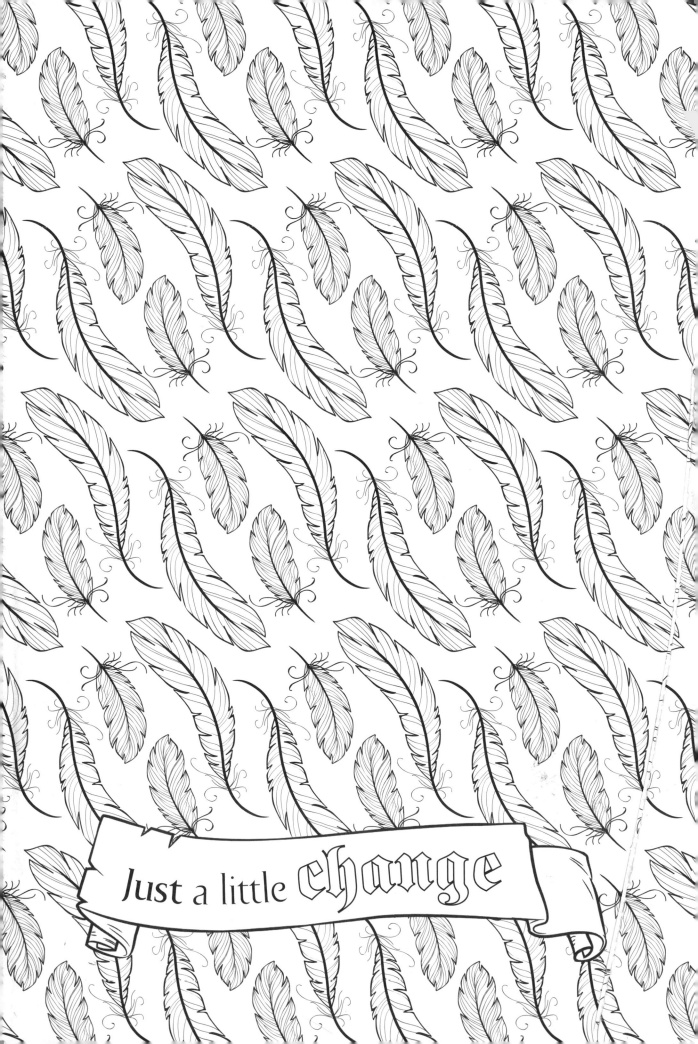

Just a little change

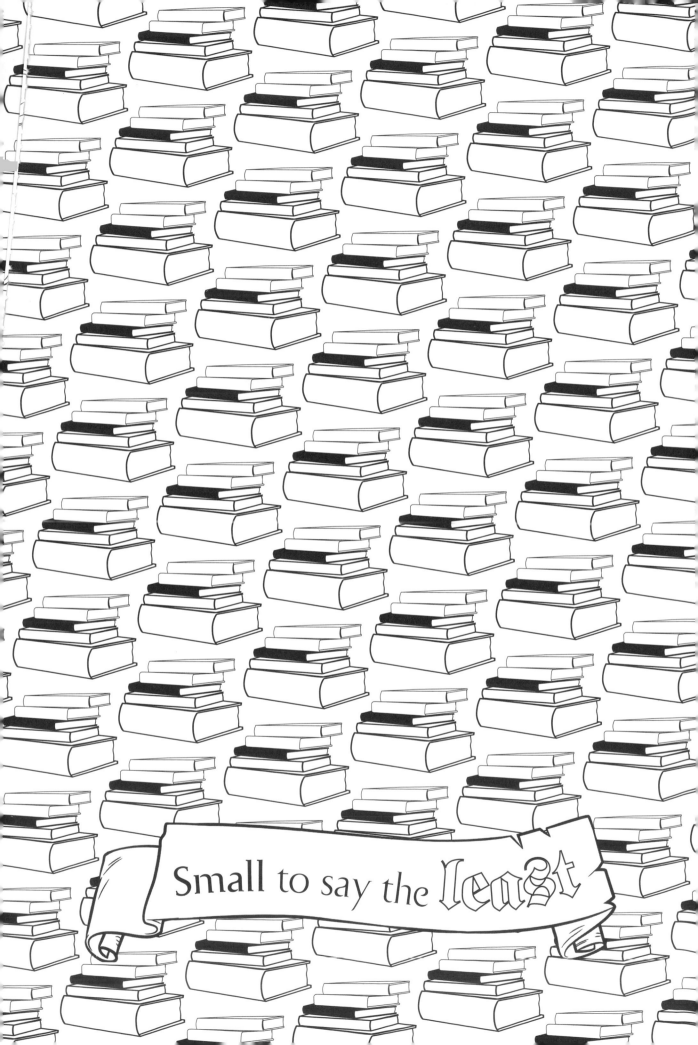

Small to say the least

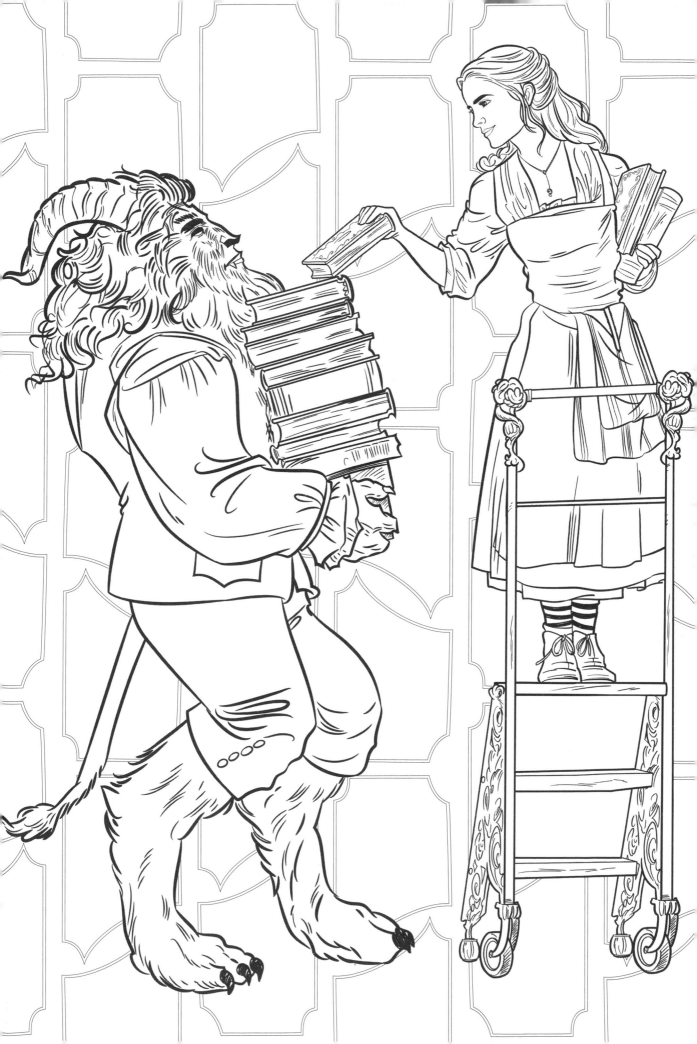

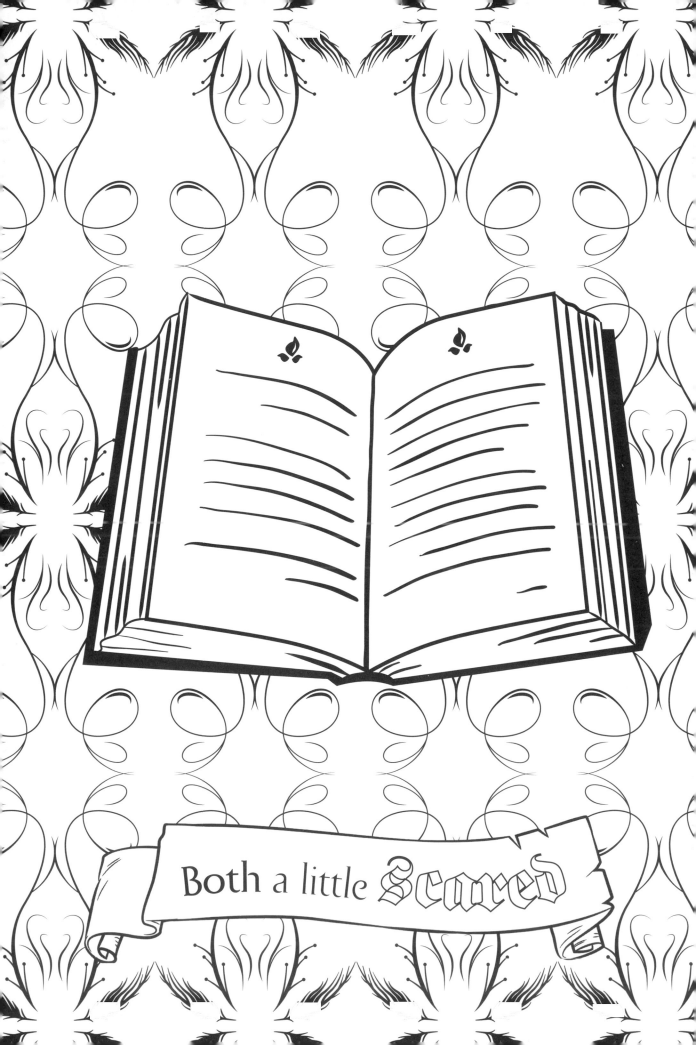

Both a little Scared

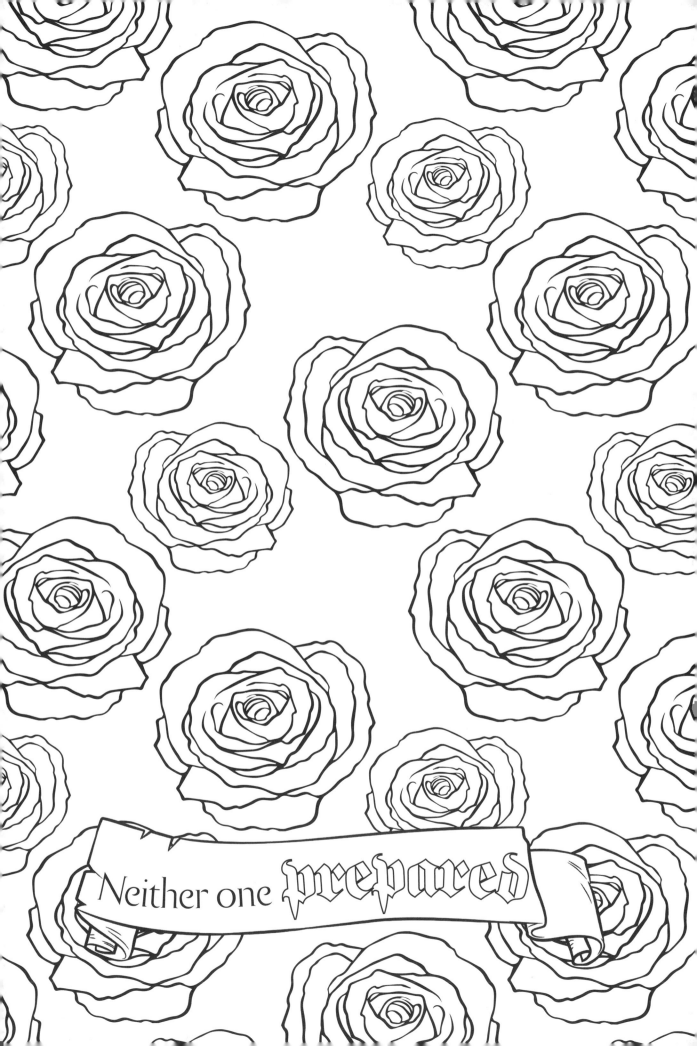

Neither one *prepared*

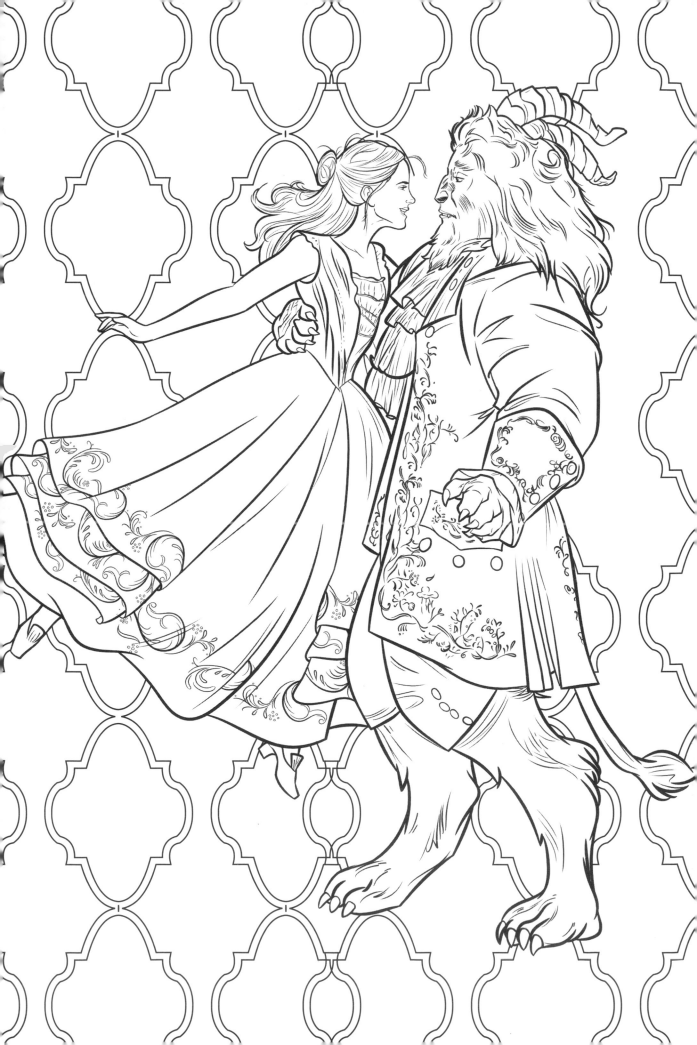